U0123014

《推手鬥士》

育成指南

"Pushing Hand Fighter"
Training Guide

林文輝　黃國龍　冷先鋒　編著
Lam Man Fai & Wong Kwok Lung　Leng Xianfeng　Author

香港氣功太極社　審定
Hong Kong qigong taiji association Approval

香港國際武術總會出版
Hong Kong International Wushu Association

《推手鬥士》育成指南
編委會名單

主　編：林文輝　黃國龍　冷先鋒

副主編：陳興緒　鄧敏佳

編　委：林　樂　許定邦　傅深桂　曾憲江　李炎雄　胡志堅

　　　　李永揚　劉家有　邱永強　梁永泰　陳雅茵　黃栢年

　　　　林家賓　張樹偉　李潔姬　鄧仲文　呂學强　謝浩章

　　　　鄧建東　陳裕平　冷　余　鄧金超　陳　璐　葉旺萍

　　　　鄭安娜　張晉豪　何偉雄　武振文

翻　譯：黃倚晴（Chloe Wong）　Philip Reeves（英國）

《推手鬥士》育成指南
目 錄

編輯委員會攝製組

前 序

太極拳源流久遠，經長年發展而成為集健身養生、技擊自衛和精神修養於一體的武術。得傳人努力整理系譜和內容，至清末葉相關記載漸多，更利傳習。今天各式太極有百花齊放之勢，中外習者眾多。20 世紀以來，太極拳在香港開枝散葉，名師如雲，人才輩出，成為香港武術文化非常重要的一部分。

近代知識傳播頗賴印刷出版。上世紀初，宗師紛紛著書立說，圖文並茂記錄解說太極義理功法，補充口授身傳之不足，效果顯著。今天創意媒體勢不可擋，然而紙本印刷自有其魅力，仍為大眾所好。我和林文輝師傅相識多年，一直對他敬佩非常。他醉心太極數十載，為王西安宗師入室弟子，並曾隨陳正雷宗師學藝。他學有所成，仍不忘誘導後進。這次與黃國龍和冷先鋒兩位志同道合者，共同編著《推手鬥士》育成指南，旨在發揚太極，有薪火相傳之功。

麥勁生

香港考評局公開考試總監

二零二一年十月

4

Foreword

With traditions dating back to centuries ago, Taiji has undergone a long evolution before becoming what is commonly acknowledged as a holistic system that threads together physical training, self-defense, and spiritual cultivation. Thanks largely to tremendous efforts by Taiji practitioners during the late Qing Dynasty (1644-1912), training manuals and records of the Taiji family tree that facilitated teaching and learning were systemically collected and organized. Taiji - taught by great masters and practiced by enthusiastic learners from different parts of the world - became an essential part of the Hong Kong martial arts culture since the early twentieth century.

In modern times, knowledge is transferred principally through publications and Taiji grandmasters, who since the last century were tireless in supplementing the traditions of oral transmission among a select few with written and pictorial works which could reach millions of people. Despite the growing dominance of digital media, traditional print remains the most popular reading format. Master Lam Man-fai, whom I very much respect, has been consumed by a passion for Taiji for decades. He is an in-chamber disciple of Grandmaster Wang Xian and has learnt different internal and external forms from Grandmaster Chen Zhenglei. I am particularly impressed by his ceaseless commitment to make Taiji learning easy and accessible to everyone. Together with Master Wong Kwok-lung and Master Leng Xianfeng, he compiles this volume with the aim of acquainting the younger generations with the beauty of Taiji.

Ricardo King Sang MAK
October, 2021

林文輝簡介

陳式太極第二十代傳人，王西安拳法第二代傳人。香港氣功太極社創會會長。自小習練太極拳，81 年在廣州中山大學隨駱佩鈺、林厚省、孫大法及林海四位老師修習氣功，並為廣州鷹爪王張展明師傅收為入室弟子，回港後，由 85 年起開始教授【金剛動靜氣功】。於 2001 年被國際太極拳王—王西安大師收列為第 51 位的徒弟，更遠赴河南陳家溝隨王西安大師學習陳式太極拳及太極氣功法，及隨陳正雷大師學習陳式春秋大刀等器械，有志發揚中國武術及氣功的古老文化，2005 年隨趙宏偉師學習形意太極拳內功法，2009 年隨少林寺第三十二代皈依弟子釋行者大師學習少林古法易筋經。

2002 年邀請王西安大師，周盟淵大師等來港，於黃大仙騰龍墟"傳統武術群英會"表演，是日吸引了 13 萬香港市民入場觀賞，傳媒廣泛報導，實為香港武林盛事。

2003 年，首本著作【金剛動靜氣功】及【金剛動靜氣功】講習碟出版。2004 年，出版著作【陳家溝健體太極—- 六十分鐘入門與實戰】

2003 年 5 月，與少林寺及香港文化促進會推動【易筋強身心連心運動健體抗炎日】及獲邀參加【全城抗炎活動日】等活動教授數以千計參加者陳家溝太極健體 8 式。

2003 年 7 月 13 日於香港大球場帶領 12,500 位保良局師生操練陳家溝太極健體 18 式，創造了一項健力士紀錄萬人太極【齊做健康操、挑戰健力士】

2007 年開始，每年舉辦太極推手賽，連續十多年推廣太極推手活動在香港發展。

2013 年開始在黃大仙及全港中、小學推廣及教授太極八式及易筋經。

Profile of Lam Man Fai

He is the twentieth generation of Chen Style Tai Chi, and the second generation of Wang Xi'an boxing, and the Founder of Hong Kong Qigong Taiji Association. He practiced Taijiquan since his childhood. In 1981, he practiced qigong with the four teachers of Luo Peijue, Lin Housheng, Sun Dafa and Lin Hai at Sun Yat-sen University in Guangzhou. He was accepted as a disciple of Guangzhou Eagle Claw King Master Zhang Zhanming. After returning to Hong Kong, he started in 1985. He began to teach King Kong Movement and Static Qigong. In 2001, he was listed as the 51st apprentice by Master Wang Xi'an, the international king of Taijiquan. He went to Chenjiagou, Henan Province to learn Chen-style Taijiquan and Taiji Qigong with Master Wang Xi'an, and Chen-style Chunqiu with Master Chen Zhenglei. He learned broadswords and other equipment, aspiring to carry forward the ancient culture of Chinese martial arts and qigong. In 2005, he studied Xingyi Taijiquan internal exercises with Zhao Hongwei. In 2009, he learned Shaolin ancient method Yijinjing with the 32nd generation of Shaolin Temple, the second generation master Shi Xingzhe.

In 2002, Master Wang Xi'an and Master Zhou Mengyuan were invited to Hong Kong to perform at the "Traditional Martial Arts Club" at the Wong Taixian Tenglong Ruins. 130,000 Hong Kong citizens watched the show. The media reported on it extensively and it was a martial arts event in Hong Kong.

In 2003, the first book "King Kong Dynamic Qigong" and "King Kong Dynamic Qigong" video discs were published. In 2004, the book "Chen Jiagou Fitness Tai Chi - 60 minutes of introduction and demonstration" was published.

On July 13, 2003, at Hong Kong Stadium, 12,500 Po Leung Kuk teachers and students practiced 18 Chenjiagou Tai Chi exercises, creating a Guinness World Record for "10,000 people doing exercises together and challenging Guinness World Records.

Since 2007, the Tai Chi Combat Competition has been held every year to promote the development of Tai Chi Combat activities in Hong Kong for more than ten consecutive years.

In 2013, Lam Man Fai to promote and teach Tai Chi in Eight Forms and Yi Jin Jing in Wong Tai Sin and all primary and secondary schools in Hong Kong.

黃國龍簡介

黃國龍 1954 年香港出生；

自幼學習南派武術，後習太極及內家拳術；

初拜吳家太極拳名師徐煥光博士學習吳家太極拳，內功，散手，推手，後再學習華獄心意六合八法拳，八卦掌，武當劍及意拳等；

2001 年拜王西安大帥（陳家溝四大金剛之一，國家級非物質文化陳式太極拳傳人）學習陳式太極拳；

2006 年跟隨毛明春教授（山西大學，國家級非物質文化鞭桿傳人）學習山西駝騾鞭桿及形意拳等；

現任職務：

香港太極總會執行監督，陳式太極拳，劍導師班教練；散手，推手及裁判班教練。

香港氣功太極社顧問，裁判長

香港中華內家拳總監，總教練，裁判長

黃師傅年輕時，常參加國內外舉辦的推手及套路比賽，皆獲得優異的成績。

黃師傅多年來熱心推廣和發展太極拳運動，作育英才，培養後俊，時常鼓勵弟子們參加比賽，增廣見聞。

Profile of Wong Kwok Lung

Wong Kwok Lung, Jeromy, born in Hong Kong at 1954

He has learned Southern Style Chinese Material Art at his early age, later on, he advanced his training in Taiji Chuen and Internal Material Arts.

His first Taiji Masster is Dr.Chui Woon Kwong whom he learned Wu Style Taiji Quan, Nai Gong, Application of Fighting (San Shou), Pushing Hand; also learned Lu Ha Ba Fa, Ba Qua Palm, Wudong Sword and Yiquan..

At year 2001,he followed Master Wang Xi On (one of Chen Taiji Quan four Iron Buda,

National Intangible Cultural Heritage in Chen Taiji Quan)to learn Chen Style Taiji Quan..

At year 2006 he followed Professor Moa Ming Chun (Professor of Shanxi University, National Cultural Intangible Heritage of Bian Gan Quan) to learn Shan Xi Whip Stick (Bian Gan) and Xing Yi Quan etc..

Duties:-

Hong Kong Tai Chi Association – Supervisor, Trainer of Chen Taiji Quan and Sword Instructor, Coach of Application of Taiji Fighting Techniques, Pushing Hand Techniques and Taiji Judge.

Hong Kong Qigong Taiji Association – Consultant and Chief Judge.

Hong Kong Ancient Internal Material Arts Association – Supervisor, Chief Judge and Chief Coach.

During Master Wong's young period, he has been actively participating in pushing Hand and Taiji Competition in Hong Kong and China and results are distinctive.

Master Wong has also been actively in promoting Taiji Competition and Taiji Pushing Hand Competition in Hong Kong. He has trained a lot of distinctive studies and always encourage them to participate in Taiji Activities and Competition to wider their scope in different aspects of Taiji and Internal Material Arts, most of his students have achieved distinctive results.

冷先鋒簡介

香港世界武術大賽發起人，當代太極拳名家、全國武術太極拳冠軍、香港全港公開太極拳錦標賽冠軍、香港優秀人才，現代體育經紀人，自幼習武，師從太極拳發源地中國河南省陳家溝第十代正宗傳人、國家非物質文化遺產傳承人、國際太極拳大師陳世通大師，以及中國國家武術隊總教練、太極王子、世界太極拳冠軍王二平大師。

國家武術套路、散打裁判員、高級教練員，國家武術段位指導員、考評員，擅長陳式、楊式、吳式、武式、孫式太極拳和太極劍、太極推手等。在參加國際、國內大型的武術比賽中獲得金牌三十多枚，其學生弟子也在各項比賽中獲得金牌四百多枚，弟子遍及世界各地。

二零零八年被香港特區政府作為"香港優秀人才"引進香港，出版發行了一系列傳統和競賽套路中英文 DVD 教學片，最新《八法五步》、《陳式太極拳》、《長拳》、《五步拳》、《陳式太極劍》、《陳式太極扇》、《太極刀》等太極拳中英文教材書，長期從事專業的武術太極拳教學，旨在推廣中國傳統武術文化，讓武術太極拳在全世界發揚光大。

冷先鋒老師本著"天下武林一家親"的理念，以弘揚中華優秀文化為宗旨，讓中國太極拳成為世界體育運動為願景，以向世界傳播中國傳統文化為使命，搭建一個集文化、健康與愛為一體的世界武術合作共贏平臺，以平臺模式運營，走產融結合模式，創太極文化產業標杆為使命，讓世界各國武術組織共同積極參與，達到在傳承中創新、在創新中共享、在共用中發揚。為此，冷先鋒老師於 2018 年發起舉辦香港世界武術大賽，至今已成功舉辦兩屆，盛況空前。

Profile of Leng Xianfeng

Master Leng is the promoter of the Hong Kong World Martial Arts Competition, a renowned contemporary master of taijiquan, National Martial Arts Taijiquan Champion, Hong Kong Open Taijiquan Champion, and person of outstanding talent in Hong Kong. A modern sports agent, Master Leng has been a student of martial arts since childhood full stop. He is a 10th generation direct descendant in the lineage of Chenjiagou, Henan province, the home of taijiquan, and inheritor and transmitter of Intangible National Cultural Heritage. Master Leng is a student of International Taiji Master Chen Shitong and Taiji Prince, Master Wang Erping, head coach of the Chinese National Martial Arts Team and World Taiji Champion.

Master Leng is a referee, senior coach and examiner at national level. Master Leng is accomplished in Chen, Yang, Wu, Wu Hao and Sun styles of taijiquan and taiji sword and push-hands techniques. Master Leng has participated in a series of international and prominent domestic taijiquan competitions in taiji sword. Master Leng has won more than 30 championships and gold medals, and his students have won more than 400 gold medals and other awards in various team and individual competitions. Master Leng has followers throughout the world.

In 2008, Master Leng was acknowledged as a person of outstanding talent in Hong Kong, published a series of tutorials for traditional competition routines on DVD and in books, the latest including "Eight methods and five steps", "Chen-style taijiquan", "Changquan", "Five-step Fist" and "Chen-style taiji sword","Chen-style taiji fan","Taijidao". Master Leng has long been engaged as a professional teacher of taijiquan, with the aim of promoting traditional Chinese martial arts to enable taijiquan to spread throughout the world.

Master Leng teaches in the spirit of "a world martial arts family", with the goal of "spreading Chinese traditional culture, and achieving a world-wide family of taijiquan." He promotes China's outstanding culture with the vision of "making taijiquan a popular sport throughout the world". As such, Master Leng has set out to to build an international business platform that promotes culture, health and love across the world of martial arts practitioners to achieve mutual cooperation and integrated production and so set a benchmark for the taiji culture industry. Let martial arts organizations throughout the world participate actively, achieve innovation in heritage, share in innovation, and promote in sharing! To this end, Master Leng initiated the Hong Kong World Martial Arts Competition in 2018 and has so far successfully held two events, with unprecedented grandeur!

飛越啟德是一個用作鼓勵和支持社區體育活動發展的慈善基金，旨在透過體育及健體相關活動，促進及推廣身心健康，造福社群，並積極支持創建或舉辦各類型體育活動，藉以提供予各階層人士參加。

"Kai Tak Sports Initiative" (KTSI) is a charitable foundation aimed to advance and promote physical and mental health for the benefit of the Hong Kong community through sports and fitness related activities. It actively supports the creation and organizing a variety of sports related programmes that are open to participants from all walks of life.

目標 Objective

· 通過教育提升市民對身心健康重要性的意識
· 為不同年齡及背景的市民帶來參與運動的機會
· 啟發社區人士，透過運動，發展個人技能及專長

· To raise awareness through education on the importance of physical and mental well-being
· To provide sports opportunities to people of all ages and backgrounds
· To inspire people to develop their personal skills and expertise through sports

非常運動地帶 SportsZONE

藉一連串有系統訓練、比賽及公眾活動鼓勵大眾市民參與運動。

By introducing a series of systematic training, competitions and public activities to encourage the public to participate in sports.

非常運動學堂 SportsLAB

讓公眾透過參與富創意、互動及好玩的活動，增加對運動和健康的相關知識。

Allowing the public to increase relevant knowledge of sports and health through activities with creativity, interaction and fun.

ktsinitiative.org.hk
登記會員

Kai Tak Sports
Initiative 飛越啟德

kaitaksportsinitiative

啟德體育園 KAI TAK SPORTS PARK

作為「啟德體育園」的團隊之一，飛越啟德積極地推動社區體育活動的發展。
As one of the teams of Kai Tak Sports Park, KTSI actively promotes the development of community sports programmes.

這比賽規則首次在「飛越啟德」項目中實施，容納 5 萬人的啟德體育園正在興建中，將在 2023 年落成啟用。

太極社參與中樂團古箏節太極滙演

太極社會慶合照

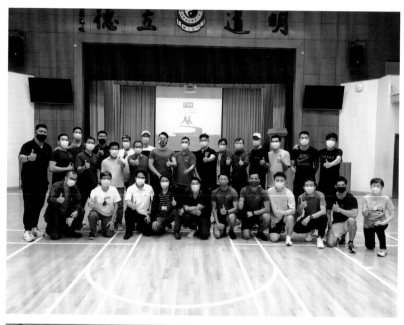

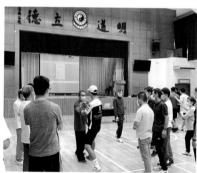
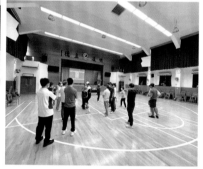

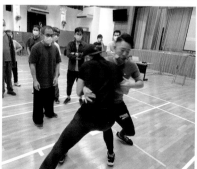

飛越啟德——教師競技推手工作坊

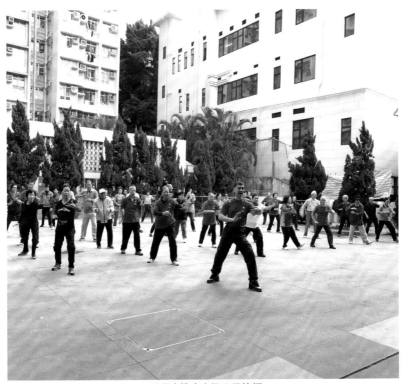

晨運班推廣太極及易筋經

出席黃大仙武術節與釋延康大師對練

與周星馳師兄一起跟王西安大師
學練太極拳

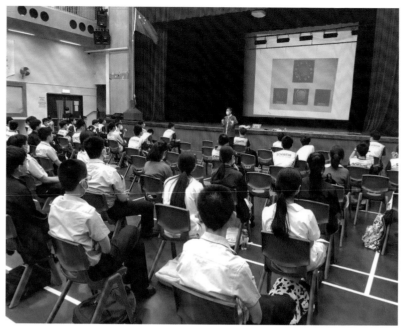

到創知中學推廣太極推手八式

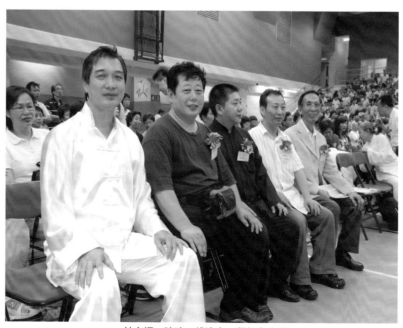

林文輝、陳瑜、傅清泉、釋行者合照

16

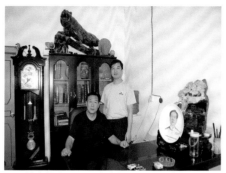
林文輝拜入王西安大師門下為入室弟子

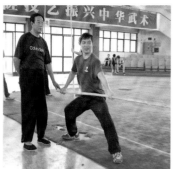
王西安大師親授太極十三桿

在陳家溝太極學院接受王西安大師及李天金師兄推手訓練

在河南陳家溝祖廟演練
太極雙刀

在黃大仙廣場推廣太極八式

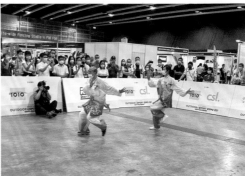

11 月 5 日，出席香港會議展覽中心運動博覽會演示：飛越啟德「回歸盃」競技推手賽 2022 的推手規則及太極拳示範。

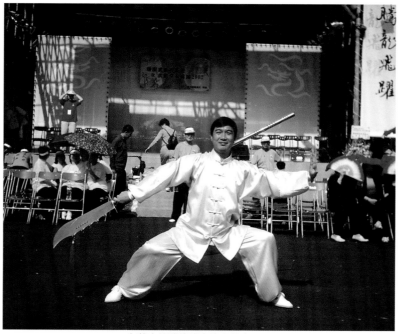

在黃大仙騰龍墟表演春秋大刀

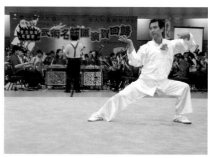

在慶賀香港回歸 10 周年表演陳式太極拳

在香港中樂團古箏節與趙宏偉大師對練

易筋經——韋馱獻杵

陳式太極拳演練

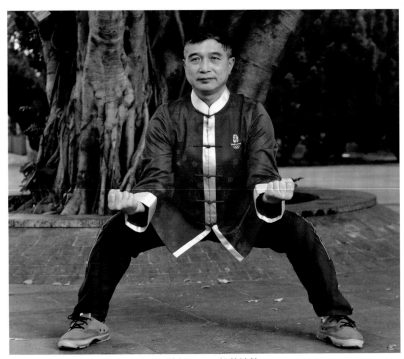

易筋經──三盤落地勢

林文輝在大球場帶領萬人太極

頒獎嘉賓

擔任頒獎嘉賓

香港太極總會新春團拜

香港太極總會祖師誕

河南黃河邊合照

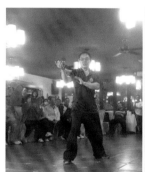
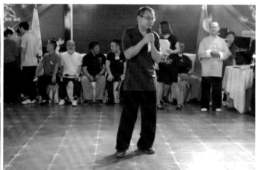

太極分享

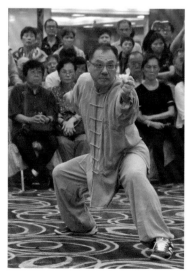

名家表演　　　　　　　　　李天金、林文輝師傅合照

太極活動抽獎

太極起程

太極欣賞會

同獲獎者合照

同王占海老師香港合照

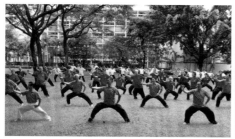

香港晨練　　　　　　　　　香港太極總會陳麗平主席（右三）

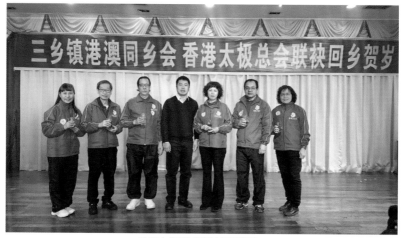

香港太極總會聯袂回鄉賀歲

中山慈善百萬行

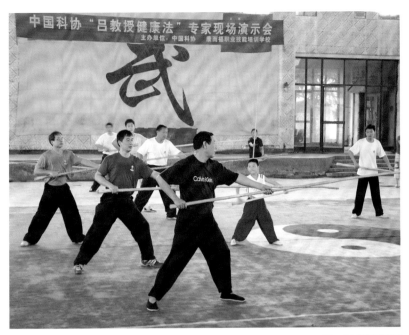

在陳家溝學藝

25

在陳家溝學藝

陳家溝和師父合影

同楊式傳人傅清泉合照

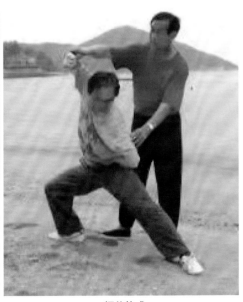

師父執式

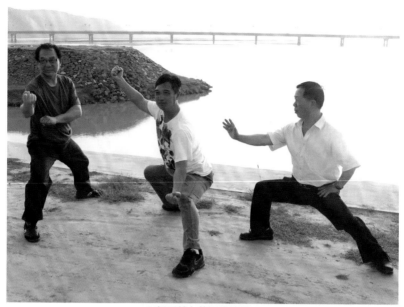

三師兄弟在黃河邊練習

同師父合照

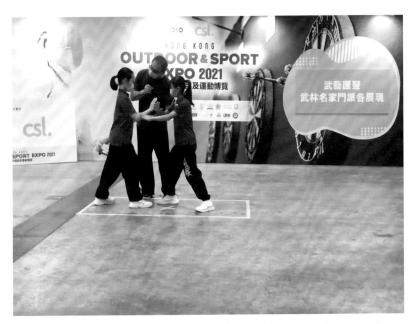

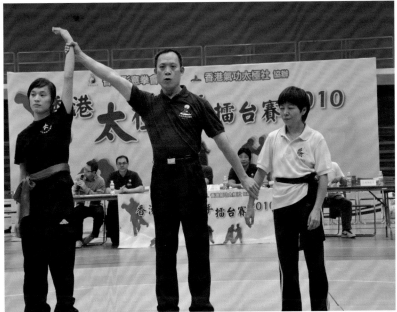

2010 年太極社首次舉辦女子推手賽冠軍獲獎

為推廣香港中小學生競技推手賽進行學生小教練培訓班

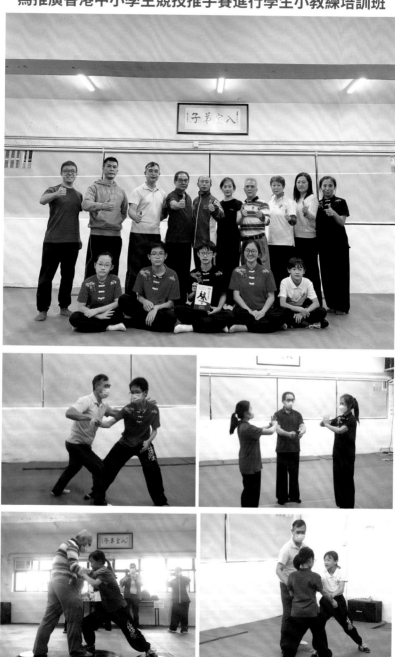

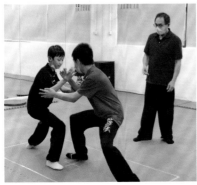

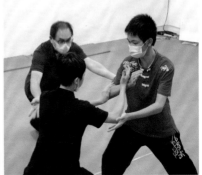

新會館

會館地址：香港九龍尖沙嘴梳士巴利道 3 號星光行 612-615 室

大活動室

小活動室

側面效果

林文輝出版的氣功太極書及教學影碟

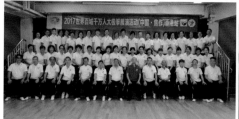

百城千萬人太極拳展演活動

松崗培訓

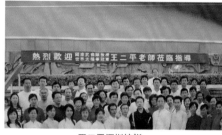

王二平深圳培訓

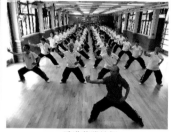

香港荃灣培訓

油天培訓

美國學生

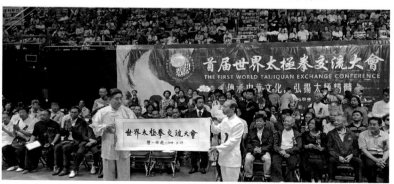

首屆世界太極拳交流大會

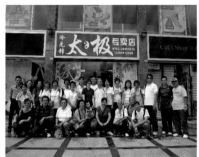
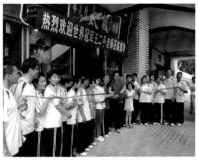

首届永城市太極拳邀請賽　　　　　　　2018首届香港太極錦標賽

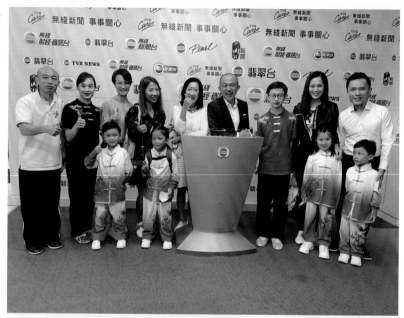

【名家薈萃】

陳世通收徒儀式

王二平老師

王西安老師

門惠豐老師

陳正雷老師

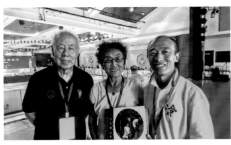

馬春喜、劉善民老師

劉敬儒老師

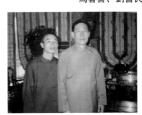

陳小旺老師

朱天才老師

李德印教授

《推手鬥士》
育成指南
"Pushing Hand Fighter"
Training Guide

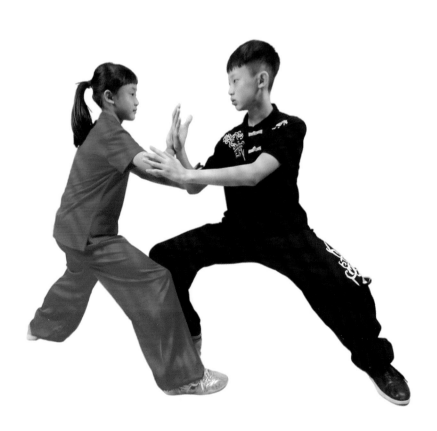

目 錄

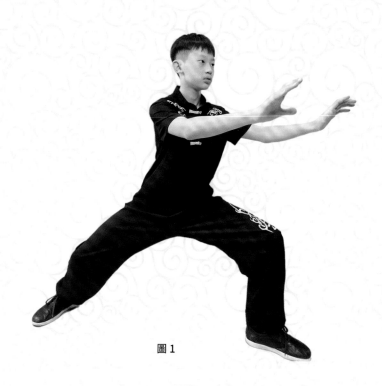

圖 1

1. 左弓步 （落地生根）

左腳在前，右腳在後，開胯，要求右膝外擺與右腳尖相對，力從地經右腳掌，右膝，腰胯，肩，手肘，傳到雙掌，向前上方推出。

1. Left bow step (roots on ground)

With the left foot in front, right foot behind. Open the hipbone, swing the right knee outward to in line with the right toes, the force should flow from the ground, through the right foot, right knee, waist and hipbone, shoulder, elbow, and to the palms, then push forward and upward.

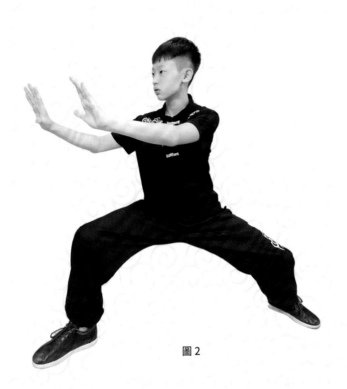

圖 2

2. 右弓步

右腳在前，左腳在後，開胯，要求左膝外擺與左腳尖相對，力從地經左腳掌，左膝，腰胯，肩，手肘，傳到雙掌，向前上方推出。

2. Right bow step

With the right foot in front, left foot behind, open the hipbone, swing the left knee outward to in line with the left toes, the force should flow from the ground, through the left foot, left knee, waist and hipbone, shoulder, elbow, and to the palms, then push forward and upward.

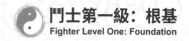

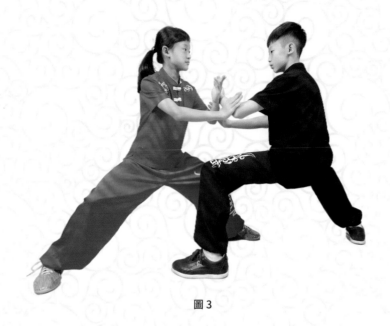

圖 3

3. 左搭手 （掤勁）

黑方：左腳在前，右腳在後，左手斜向上方以手背輕搭紅方左手背，右手輕搭紅方左手肘。要求兩手似抱樹，擬似抱氣球向前向上膨脹將紅方浮起。

紅方與黑方動作相同，方向相反。

3. Left hand upon hand (ward-off strength)

Black side: With the left foot in front, right foot behind, move the left hand diagonally upward, lightly attach the back of the hand to the back of the red side's left hand, and lightly attach the right hand to the red side's left elbow. It is required to hold both hands like holding a tree, and to inflate the red side forward and upward as if holding a balloon.

The red side and the black side have same movements, but in opposite directions.

圖 4

4. 右搭手

黑方：右腳在前，左腳在後，右手斜向上方以手背輕搭紅方右手背，左手輕搭紅方右手肘。要求兩手似抱樹，擬似抱氣球向前向上膨脹將紅方浮起。

紅方與黑方動作相同，方向相反。

4. Right hand upon hand

Black side: With the right foot in front, left foot behind, move the right hand diagonally upward, lightly attach the back of the hand to the back of the red side's right hand, and lightly attach the left hand to the red side's right elbow. It is required to hold both hands like holding a tree, and to inflate the red side forward and upward as if holding a balloon.

The red side and the black side have same movements, but in opposite directions.

試力練習：
Exercises to test strength:

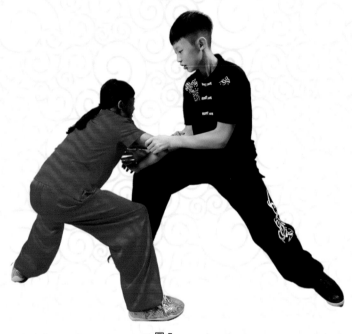

圖 5

雙人推手試力：黑方推紅方，以 10 次為 1 組，交換紅方推黑方，再左右交替練習，左右各 2 組。

Two-person pushing hand strength test: Black side pushes the red side, 10 times as a group. Then, red side pushes the black side, and alternately practice left and right side with 2 groups on each side.

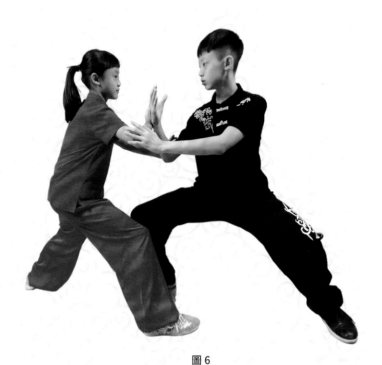

圖 6

雙人掤手試力：黑方掤紅方，以 10 次為 1 組，交換紅方掤黑方，再左右交替練習，左右各 2 組。

Two-person ward-off strength test: Black side wards the red side off, 10 times as a group. Then, red side wards the black side off, and alternately practice left and right side with 2 groups on each side.

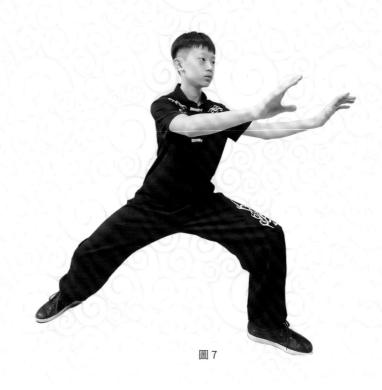

圖 7

單人推手試力：黑方推牆（或樹）以 10 次為 1 組，再左右交替練習，左右各練 2 組。

One-person pushing hand strength test: Black side pushes a wall (or a tree) 10 times as a set, and then alternately practice left and right side with 2 sets on each side.

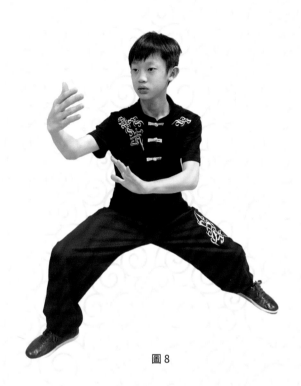

圖 8

單人掤手試力：黑方外掤牆（或樹）以 10 次為 1 組，再左右交替練習，左右各練 2 組。

One-person ward-off strength test: Black side ward a wall (or a tree) off outward with 10 times as a set, then alternately practice left and right side with 2 sets on each side.

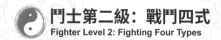
1. 玉女穿梭： （前上托：恨地無環）

1. Jade girl shuttling: (front lift up: hate without ring on the ground)

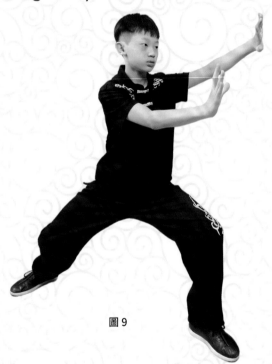

圖 9

左穿梭

左腳在前，右腳在後，左手上掤，右手向前向上推出，擬似右手臂挽著地上的鐵環向上將大地拔起，力從地經右腳掌，右膝，腰胯，肩，手肘，傳到右掌，向左前上方推出。

Left shuttling

With the left foot in front, right foot behind, ward the left hand off upward, push the right hand forward and upward, as if the right arm is holding an iron ring on the ground to pull the earth up. The force should flow from the ground, through the right foot, right knee, waist and hipbone, shoulder, elbow, and to the right palm, then push it to the top left front.

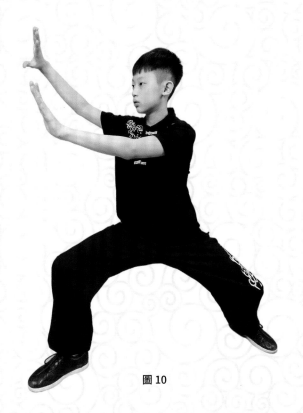

圖 10

右穿梭

右腳在前，左腳在後，右手上掤，左手向前向上推出，擬似左手臂挽著地上的鐵環向上將大地拔起，力從地經左腳掌，左膝，腰胯，肩，手肘，傳到左掌，向右前上方推出。

Right shuttling

With the right foot in front, left foot behind, ward the right hand off upward, push the left hand forward and upward, as if the left arm is holding an iron ring on the ground to pull the earth up. The force should flow from the ground, through the left foot, left knee, waist and hipbone, shoulder, elbow, and to the left palm, then push it to the top right front.

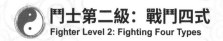
2. 摟膝拗步：（前下推）

2. Brush knee and twist step: (Push to the bottom left)

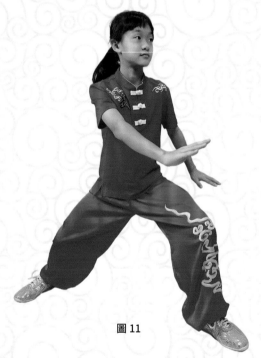

圖 11

左摟膝拗步

左腳在前，右腳在後，左手下掤，右手向前向下推出，力從地經右腳掌，右膝，腰胯，肩，手肘，傳到右掌，向左前下方推出。

Left brush knee and twist step

With the left foot in front, right foot behind, ward the left hand off downward, push the right hand forward and downward, the force should flow from the ground, through the right foot, right knee, waist and hipbone, shoulder, elbow, and to the right palm, then push it to the lower front left.

圖 12

右摟膝拗步

右腳在前，左腳在後，右手下掤，左手向前向下推出，力從地
經左腳掌，左膝，腰胯，肩，手肘，傳到左掌，向右前下方推出。

With the right foot in front, left foot behind, ward the right hand off downward,
push the left hand forward and downward, the force should flow from the
ground, through the left foot, left knee, waist and hipbone, shoulder, elbow,
and to the left palm, then push it to the lower front right.

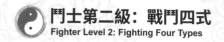
3. 倒捲肱： （後下拉：恨天無把）

3. Rewind reeling forearm: (pull down backward: hate without a handle in the sky)

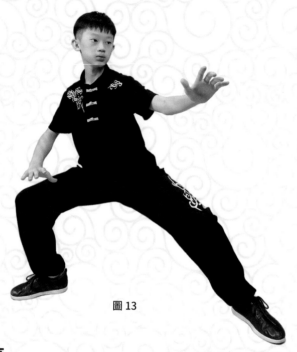

圖 13

左倒捲肱

左腳在前，右腳在後，重心移向右腳，右手下捋，左手由前向後向下拉，擬似左手臂挽著天上的鐵環向下將天拉塌，力從地經左腳掌，左膝，腰胯，肩，手肘，傳到左掌，向右後下方拉回。

Left rewind reeling forearm

With the left foot in front, right foot behind, the center of gravity is shifted to the right foot, lower the right hand, pull the left hand from the front to back and to the bottom, as if the left arm is holding an iron ring in the sky and pulling the sky down, the force should flow from the ground, through the left foot, left knee, waist and hip, shoulder, elbow, and to the left palm, pull it back to the lower back right.

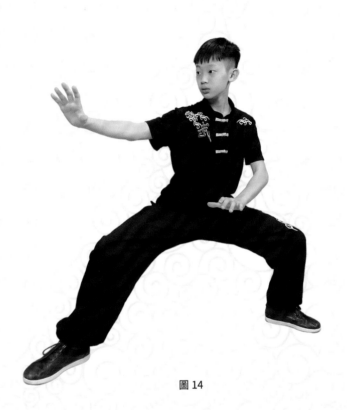

圖 14

右倒捲肱

右腳在前，左腳在後，重心移向左腳，左手下捋，右手由前向後向下拉，擬似右手臂挽著天上的鐵環向下將天拉塌，力從地經右腳掌，右膝，腰胯，肩，手肘，傳到右掌，向左後下方拉回。

Right rewind reeling forearm

With the right foot in front, left foot behind, the center of gravity is shifted to the left foot, lower the left hand, pull the right hand from the front to back and to the bottom, as if the right arm is holding an iron ring in the sky and pulling the sky down, the force should flow from the ground, through the right foot, right knee, waist and hipbone, shoulder, elbow, and to the right palm, pull it back to the lower back left.

4. 雲手：（左右搖山）

4. Waving hands like clouds: (Shake the mountain left and right)

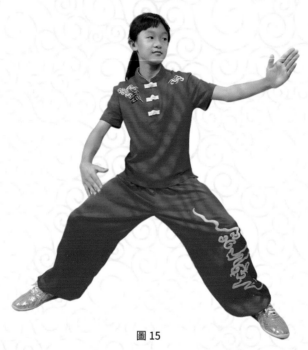

圖 15

左雲手

左腳在前，右腳在後，右手後拉，左手由左向右推移，擬似左手臂將石山推向右移，力從地經右腳掌，右膝，腰胯，肩，手肘，傳到左前臂，向右後方旋轉推移。

Left waving hands like clouds

With the left foot in front, right foot behind, pull the right hand backward, move the left hand from the left to the right, as if the left arm pushes a stone mountain to the right, the force should flow from the ground, through the right foot, right knee, waist and hipbone, shoulder, elbow, and to the left forearm, rotate and move it to the rear right.

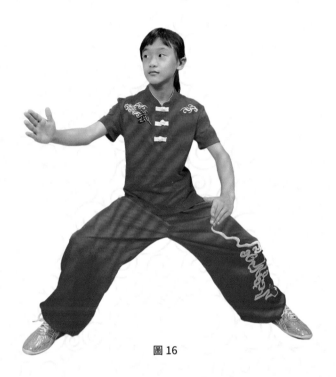

圖 16

右雲手

右腳在前，左腳在後，左手後拉，右手由右向左推移，擬似右
手臂將石山推向左移，力從地經左腳掌，左膝，腰胯，肩，手肘，
傳到右前臂，向左後方旋轉推移。

Right waving hands like clouds

With the right foot in front, left foot behind, pull the left hand backward, move
the right hand from the right to the left, as if the right arm pushes a stone
mountain to the left, the force should flow from the ground, through the left
foot, left knee, waist and hipbone, shoulder, elbow, and to the right forearm,
rotate and move it to the rear left.

四式對練
Four-way exercise

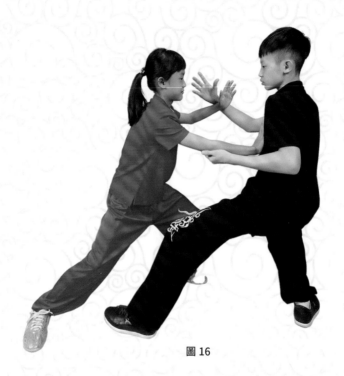

圖 16

1. 玉女穿梭
左穿梭：紅方左腳在前右腳在後，以左手向上掤起黑方右手，紅方右手按黑方胸前向左上方推掌，將黑方推出後界之外。

2.Jade girl shuttling
Left shuttling: With red side's left foot in front and right foot behind, left hand ward black side's right hand off upward, red side presses black side's chest with right hand and pushes the palm to the upper left, pushing black side out of the back boundary.

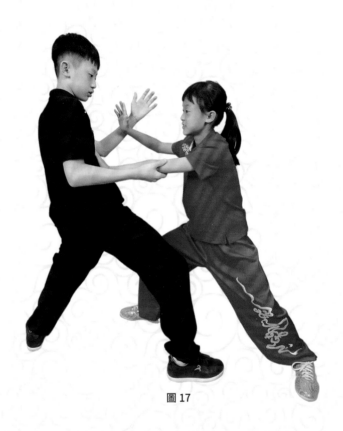

圖 17

右穿梭：紅方右腳在前左腳在後，以右手向上掤起黑方左手，紅方左手按黑方胸前向右上方推掌，將黑方推出後界之外。

Right shuttling: With red side's right foot in front and left foot behind, right hand ward black side's left hand off upward, red side presses black side's chest with left hand and pushes the palm to the upper right, pushing black side out of the back boundary.

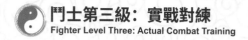
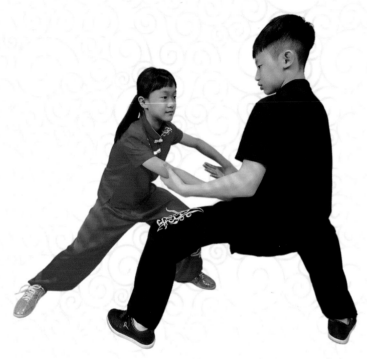

圖 16

2. 摟膝拗步

左摟膝拗步：紅方左腳在前右腳在後，以右手向外掤起黑方左手，紅方左手按黑方胯關節前向右下方推掌，將黑方推倒在地。

2.Brush knee and twist step

Left brush knee and twist step: With red side's left foot in front and right foot behind, ward black side's left hand off outwards with right side, red side presses black side's hipbone joint with left hand and pushes the palm to the lower right, pushing black side to the ground.

圖 19

右摟膝拗步: 紅方右腳在前左腳在後, 以左手向外掤起黑方右手, 紅方右手按黑方胯關節前向左下方推掌, 將黑方推倒在地。

Right brush knee and twist step: With red side's right foot in front and left foot behind, ward black side's right hand off outwards with left hand, red side presses black side's hipbone joint with right hand and pushes the palm to the lower right, pushing black side to the ground.

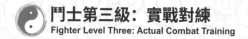
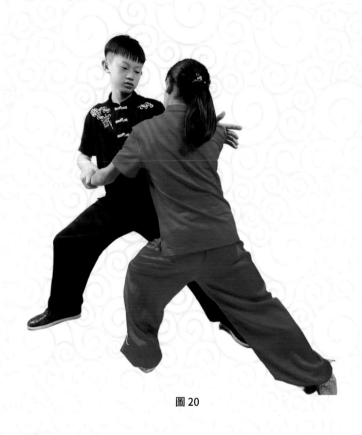

圖 20

3. 倒捲肱

左倒捲肱：黑方左腳在前右腳在後，重心後移至右腳，以右手向外向後纏拿紅方左手，黑方左手按紅方右肩膊向左後方下捋，將紅方拉倒在地。

3.Rewind reeling forearm

Left rewind reeling forearm: With black side's left foot in front and right foot behind, the center of gravity is moved back to the right foot, and wrap around red side's left hand outwards and backwards with right hand, press red side's right shoulder with black side's left hand and roll it back to the rear left, pull red side to the ground.

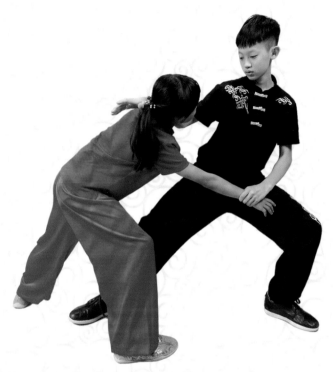

圖 21

右倒捲肱：黑方右腳在前左腳在後，重心後移至左腳，以左手向外向後纏拿紅方右手，黑方右手按紅方左肩膊向右後方下捋，將紅方拉倒在地。

Right rewind reeling forearm: With black side's right foot in front and left foot behind, the center of gravity is moved back to the left foot, and wrap around red side's right hand outwards and backwards with left hand, press red side's left shoulder with black side's right hand and roll it back to the rear right, pull red side to the ground.

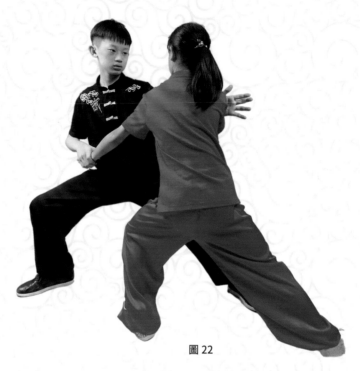

圖 22

4. 雲手

左雲手：黑方左腳在前右腳在後，重心後移至右腳，以右手向外向後纏拿紅方左手，黑方左手前臂按紅方右上臂或穿入腋下按紅方胸腰向右方推移，將紅方推出右側界之外。

4.Waving hands like clouds

Left waving hands like clouds: With black side's left foot in front and right foot is behind, the center of gravity is moved back to the right foot, wrap around red side's left hand outwards and backwards with right hand, press the red side's upper right arm or penetrate into the armpit and press the red side's chest and waist with black side's left forearm to the right, push the red side out of the right boundary.

右雲手：黑方右腳在前左腳在後，重心後移至左腳，以左手向外向後纏拿紅方右手，黑方右手前臂按紅方左上臂或穿入腋下按紅方胸腰向左方推移，將紅方推出左側界之外。

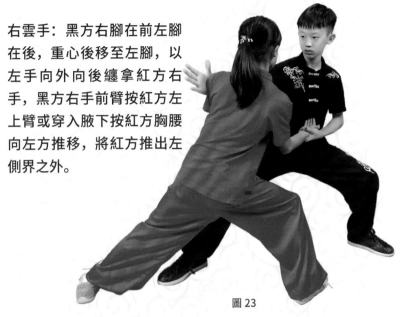

圖 23

Right waving hands like clouds: With black side's right foot in front and left foot behind, the center of gravity is moved back to the left foot, wrap around red side's right hand outwards and backwards with left hand, press the red side's upper left arm or penetrate into the armpit and press the red side's chest and waist to the left with black side's right forearm, push the red side out of the left boundary.

* 混合對練：將推手四式練習純熟之後就可以隨機運用對練，互相聽勁，不要用死力對頂，以旋轉腰胯及掤勁，達到借力打力的效果。

*Mixed pair training: After practicing the four movement of pushing hands, you can randomly pair training with others, feel the force of each other, don't use hard strength to against each other, rotate the waist and use the force of ward off to achieve the effect of leveraging the force.

1. 上盤：臥虎推山（肘不離肋）

1. Upper body: Crouching tiger pushes the mountain (elbow does not leave the ribs)

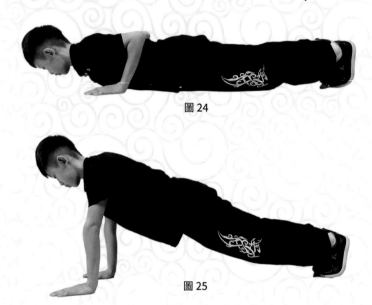

圖 24

圖 25

吸氣，兩掌相距與肩略寬曲肘下臥，肘要貼近兩肋，腳腰及背要成一直線，胸要離地。

呼氣，兩掌推地，身體離地上升，腳腰及背要成一直線。

Inhale, Palms apart and slightly wider than shoulders, bend and lay the elbows down, elbows should be close to the ribs, the claf and back should be in line, and the chest should be off the ground.

Exhale, push both palms to the ground, and lift the body off the ground, with the claf and back of the feet in line.

\# 以上動作重複 20 次為一組，每次練 2 組。

#Repeat the above movement 20 times as a group, and practice 2 groups each time.

2. 下盤：蹲龍托天（龍脊中正）

2. Lower body: Squatting dragon holding up the sky (Centered dragon back)

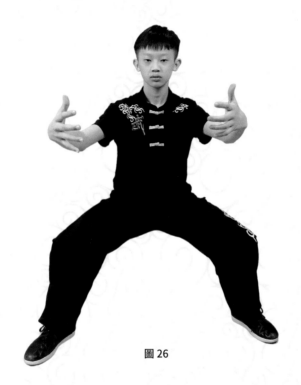

圖 26

抱樹樁：兩腳開立，膝與足尖垂直相對，腰脊中正，收頷頂頭懸，肩鬆下沉，兩臂與地面平行，兩掌手相對成抱樹狀。

Hugging tree stump: Stand with the feet open, knees and toes perpendicular to each other, waist and spine centered, hold down the chin, head up, relax and sink the shoulders, arms parallel to the ground, both palms facing each other and hold like hugging a tree.

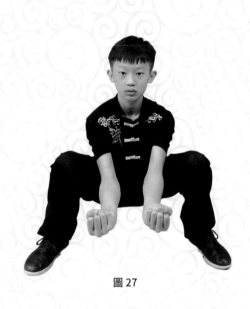

圖 27

吸氣，下蹲，兩掌變握拳，兩臂同地面平行相合似捧物狀。

Inhale, squat down, change both palms into fists. Both arms are parallel to the ground, like holding something.

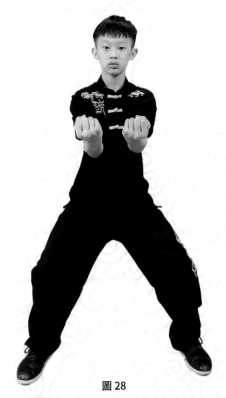

圖 28

呼氣，站立，兩掌握拳，兩臂同地面平行相合似將重物捧起。

Exhale, stand up, hold fists with both palms, with both arms parallel to the ground, as if lifting up a heavy object.

以上動作重複 20 次為一組，每次練 2 組。

#Repeat the above actions 20 times as a group, and practice 2 groups each time.

3. 中盤：抖動山移（抖桿）

3. Middle of the body: Shake and move the mountain (shaking pole)

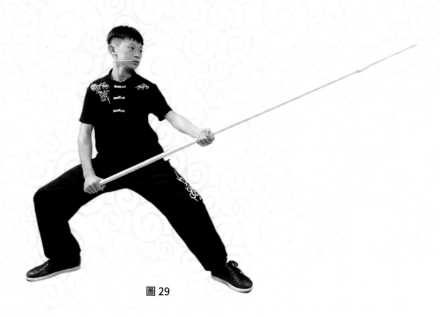

圖 29

左抖桿：

左腳在前右腳在後，重心後移至右腳，

兩手臂伸直握桿，左手拳面向上，右手拳面向下，腰脊中正，旋轉腰胯，抖動長桿使桿尖震動。

Left shaking pole:

With the left foot in front and right foot behind, the center of gravity is moved back to the right foot.

Hold the pole with straighten arms, with the face of the left fist facing up, the face of the right fist facing down, and the waist and spine centered. Rotate the waist and hipbones, shake the long pole to make the tip of the pole vibrate.

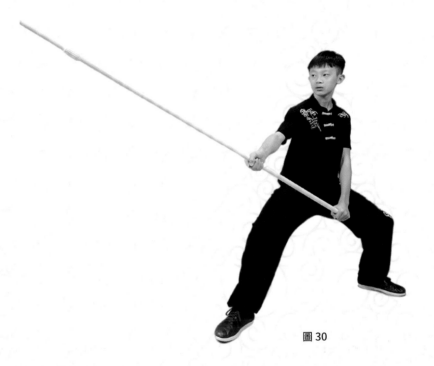

圖 30

右抖桿：

右腳在前左腳在後，重心後移至左腳，
兩手臂伸直握桿，右手拳面向上，左手拳面向下，腰脊中正，
旋轉腰胯，抖動長桿使桿尖震動。

Right shaking pole:

With the right foot in front and left foot behind, the center of gravity is moved back to the left foot.

Hold the pole with straighten arms, with the face of the right fist facing up, the face of the left fist facing down, and the waist and spine centered. Rotate the waist and hipbones, shake the long pole to make the tip of the pole vibrate.

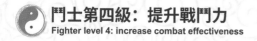
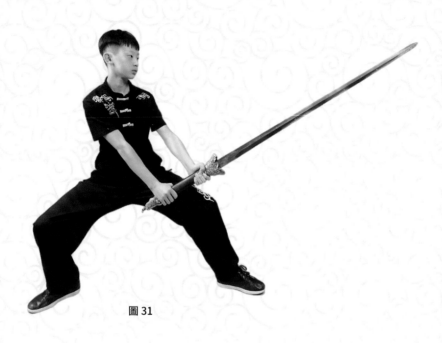

圖 31

左抖劍：

左腳在前右腳在後，重心後移至右腳，
兩手臂伸直握劍，左手拳面向上，右手拳面向下，腰脊中正，
旋轉腰胯，抖動長劍使劍尖震動。

Left shaking sword:

With the left foot in front and right foot behind, the center of gravity is moved back to the right foot.

Hold the sword with straighten arms, with the face of the left fist facing up, the face of the right fist facing down, and the waist and spine centered.

Rotate the waist and hipbones, shake the long sword to make the tip of the sword vibrate.

圖 32

右抖劍:

右腳在前左腳在後，重心後移至左腳，

兩手臂伸直握劍，右手拳面向上，左手拳面向下，腰脊中正，

旋轉腰胯，抖動長劍使劍尖震動。

Right shaking sword:

With the right foot in front and left foot behind, the center of gravity is moved back to the left foot.

Hold the sword with straighten arms, with the face of the right fist facing up, the face of the left fist facing down, and the waist and spine centered. Rotate the waist and hipbones, shake the long sword to make the tip of the sword vibrate.

以上四動作各抖動 30 秒為一組，每次練 2 組。

Shake for 30 seconds as a group for the above movements, and practice 2 groups each time.

競技推手規則（飛越啟德—回歸盃競技推手賽）

Competitive pushing hand rules (Kai Tak Sports Initiative – Returning Cup Competitive Pushing Hand Competition)

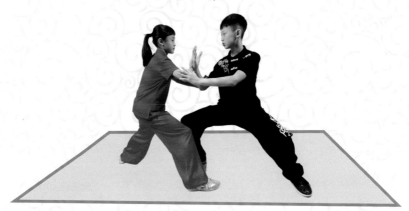

紅黑雙方互搭手，在 1 米 x2 米的擂台上競技推手，一決勝負。

The red and black teamed up with each other place their hand upon hand, compete in a 1m x 2m arena of pushing hand for a showdown.

< 甲 > 比賽規則　<A>competition rules

1. 在比賽中必須貫徹『粘連黏隨』、『以柔克剛』及『持巧不持力』的原則。

2. 採用『掤、捋、擠、按、採、挒、肘、靠』和『引進落空』、『閃戰惊彈』的技巧進行比賽，達到對方失去平衡而倒地或被擊下擂台而得分的目的。

3. 可使用脫手 / 解脫推掌進攻（非故意打擊對手）。

1. The principles of "stick, link, adhere, follow", "overcoming hardness with softness" and "with skills but not with force" must be implemented in the competition.

2. Use the skills of "ward-off, rollback, push, press, grab, split, elbow strike and shoulder strike" and "introduce to fall" and "flash and startle bullets" in the competition so that the opponent will lose the balance and fall to the ground or being knocked off the arena, and hence earn points.

3. Hand off/release and push palms movements can be used for offense (unintentionally hitting the opponent).

< 乙 > 比賽場地：地上舖有塑膠軟墊或厚地毡。在 1 米 X 2 米的範圍內雙方對壘，不得起腳掃、勾、踢、絆及挂腳。

Competition venue: The ground is covered with soft plastic cushions or thick carpets, with confrontation between two sides within a range of 1 meter X 2 meters. Lifting up, sweeping, hooking, kicking, tripping and hanging feet are not allowed.

< 丙 > 比賽局數及時間：每次比賽以兩局為限，每局淨比賽時間為 1 分鐘，裁判叫停不計時，兩局之間休息 1 分鐘。

<C> Number of rounds of the competition and time: Each competition is limited to two rounds; the net time of each round is 1 minute. No time is counted when the referee calls a stop, and there is a 1-minute rest between the rounds.

< 丁 > 比賽服飾: 短袖運動衫及長運動褲。大會提供紅色及黑色腰帶〈以抽籤決定紅方或黑方〉。

<D>Competition clothing: short-sleeved sports shirts and long sports pants. The conference will provide red and black colour belts (the red or black side will be determined by lottery).

< 戊 > 比賽方法及攻擊部位

1. 第一局右腳在前，互搭右手；第二局互換方向，左腳在前，互搭左手。每局開始時，運動員前腳同踩於擂台中心點。當擂台上主裁判發出『開始』口令後，雙方搭手後即可進攻。比賽中，裁判叫停，再開始時『甲乙』雙方互搭手待裁判叫『開始』，即可進攻。

2. 攻擊部位限於頸部以下，恥骨以上軀幹和上肢部位。

3. 不可勾腳、絆腳或挂腳。

<E> Competition method and attack area

1. In the first round, the right foot is in front, and the right hand of both sides is placed upon each other; in the second round, the direction is reversed, with the left foot in front, and the left hand of both sides is placed upon each other. At the beginning of each round, the forefoot of both athletes should be put on the center point of the arena. When the chief referee issues the "start" command in the arena, the two sides can start to offend after they placed their hand upon others' hand. During the competition, if the referee calls a stop, and it starts again, both sides of "A and B" should place their hand upon

others' hand and wait for the referee to call "start" to offend immediately.

2. The attack area is limited to the neck below, the trunk above the pubic bone and upper limbs.

3. Do not hook, trip or hang the feet.

<己> 得分

1. 以明顯的技術動作使對方附加支撐（手、膝或身體其他部份著地）或倒地者 得 3 分。

2. 使對方單腳離開擂台界線者得 1 分。

3. 使對方雙腳離開擂台界線者得 2 分。

4. 雙方離開擂台界線互不得分。 雙方同時倒地互不得分。

5. 雙方先後倒地，後倒地者得 1 分。

<F> Score

1. Obvious technical movements which make the opponent gets additional support (hands, knees or other parts of the body touch the ground) or falls to the ground will score 3 points.

2. The one who makes the opponent leaves the arena boundary with one foot scores 1 point.

3. The one who makes the opponent's leaves the arena boundary with both feet scores 2 points.

4. Both sides do not score when they both left the arena boundary. Both sides do not score when they fell to the ground at the same time.

5. If both sides fell to the ground one after the other, the one who fell to the ground later gets 1 point.

<庚> 罰則

1. 凡有以下行為者均會給予勸告：

使用硬拉、硬拖或硬抱者。

雙手或單手插入對方腋下同時超出對方脊中線者。

故意造成對方犯規者。

單、雙手抓住對方衣服或雙手死握對方者〈順勢除外〉。

未發『開始』口令進攻對方，或已發『停止』口令仍進攻對方者。

比賽中進行場外指導者。

每勸告一次，對方得 0.5 分，被勸告 6 次者，判對方獲勝。

2. 凡違反以下規定者均被給予警告：

使用拳打、頭撞、撅肘、擒拿、抓頭髮、點穴、肘尖頂、撈襠或扼喉等動作者。

攻擊規則中規定以外的身體部位者。

比賽中對裁判不禮貌或不服從裁判者。 警告一次對方得 1 分，被警告 3 次者，判對方獲勝。

3. 出現以下行為者被取消比賽資格：在比賽場上對裁判員謾罵、圍攻或侮辱裁判者。 故意攻擊對方嚴禁攻擊部位者。

<G> Penalty

1. Anyone who has the following behaviors will be given advice:

Those who pull, drag or hug others hard.

Those who insert both hands or one hand into the opponent's armpit and at the same time beyond the midline of the opponent's spine.

Those who deliberately cause the opponent to foul.

Those who grab the clothes of the opponent with one hand or both hands, or hold the opponent with both hands tightly (except for following the opponents' move).

Those who offend others before the referee issuing the "start" command, or after the referee issuing the "stop" command.

Those who coach off the court during the competition.

0.5 points is awarded for each time if the opponent is warned, and will win the competition if the opponent is warned for 6 times.

2. Anyone who violates the following regulations will be given a warning:

Those who use punches, head bumps, elbows, grappling, hair grabs, acupuncture points, elbow points, crotch or throat choking.

Those who wait for the movements of the opponent.

Those who attack on body parts other than those specified in the rules.

Those who are rude to or disobey the referee during the competition. One point is awarded to the opponent for one warning. The opponent will win the competition if being warned for 3 times.

3. Those who have the following behaviors will be disqualified from the competition: verbal abuse, besieging or insulting the referee on the competition field, deliberately attack the parts of the forbidden area of the opponent.

鬥士下山：參加戰鬥
Fighter descends the mountain: take part in the battle

< 辛 > 評定勝負

1. 每場任何一方取得 15 分者為優勢勝利。

2. 比賽中因對方犯規造成受傷，經裁判長判以不能繼續比賽者，判受傷者獲勝。

3. 比賽中因傷不能堅持比賽者，判對方獲勝。

4. 比賽中，運動員、教練員要求棄權時，判對方勝。

5. 比賽結束後，根據運動員的得分多少確定名次，得分多者為勝方。

6. 仍相等時，以體重輕者為勝。

7. 仍相等時，分別按警告，勸告多少計算，少者為勝。

8. 仍相等時，淘汰制比賽時再增加比賽局數，以先得分者為勝。

9. 申訴程序及要求參賽隊如果對裁判的判決結果有異議，以仲裁委員會裁決為最終裁決，各隊必須服從。

<H>Judging the winner

1. In each competition, any side scores 15 points as the dominant victory.

2. Injury due to a foul by the opponent during the competition, and the chief referee judges that the competition cannot be continued, the injured one will be judged to win.

3. During the competition, those who are unable to hold on due to injury will be judged to the opponent wins.

4. In the competition, if an athlete or coach requests to abstain, the opponent will be judged to win.

5. After the competition is over, the ranking will be determined according to the scores of the athletes, and the winner is the one with the most scores.

6. If two sides get the same score, the one with the lighter weight wins.

7. If two sides still get the same score, calculate the number of warnings respectively, and the lesser wins.

8. If two sides still get the same score, the number of rounds will be increased in the elimination system competition, and the first to score will win.

9. If there are any objections to the appeal procedure or any disagreements with the referee's decision by the team that requested to join the competition, the decision of the arbitration committee shall be the final ruling, and each team must obey.

< 壬 > 競賽中的禮儀

1. 介紹參賽者時，參賽者須向觀眾行抱拳禮。

2. 每局比賽開始時，參賽者互相行抱拳禮。

3. 宣佈結果後，參賽者先互相行抱拳禮，再向台上裁判員行抱拳禮。

<I> Etiquette in the competition
1. When introducing contestants, contestants should salute the audience with fist.
2. At the beginning of each round, the contestants should salute each other with fist.
3. After announcing the result, the contestants should first salute each other with fist, and then salute the referees on stage with fist.

< 癸 > 棄權

1. 比賽期間，比賽中受傷或生病未能出賽者或

2. 比賽進行時，參賽者實力懸殊，教練或參賽者可舉手要求棄權。

3. 不能按時參加磅體重者。

4. 出賽當日 3 次召集仍未報到或報到後擅自離開，不能按時上場者，作棄權論。

<J> Abstaining
1. During the competition, those who were injured or ill during the competition failed to attend the competition or
2. When the competition is in progress, and the ability and strength of the contestants is very different, the coach or contestant can raise their hands and request to abstain.
3. Those who cannot participate in the pound weight on time.
4. Those who fail to report for 3-time calling on the day of the competition or leave without permission after reporting, and who cannot play on time will be considered as abstention.

* 服裝 : 參賽服裝自備。款式、顏色不限，以莊重及富民族色彩為準。

*Clothing: The contestant should bring their own clothes. Styles and colors are not limited, subject to solemn and rich national colors.

鬥士下山：參加戰鬥
Fighter descends the mountain: take part in the battle

得分範例: Examples of scoring:

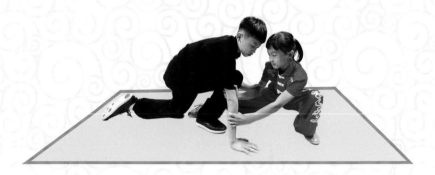

黑方手或腳觸地，紅方得 3 分。

If the black side touches the ground with hands or feet, the red side will score 3 points.

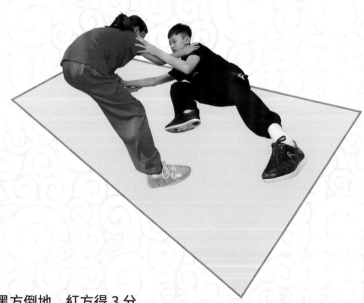

黑方倒地，紅方得 3 分。

If the black side falls to the ground, the red side will score 3 points.

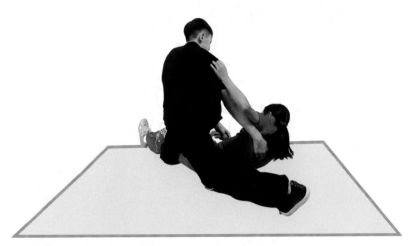

紅方倒地，黑方得 3 分。

If the red side falls to the ground, the black side will score 3 points.

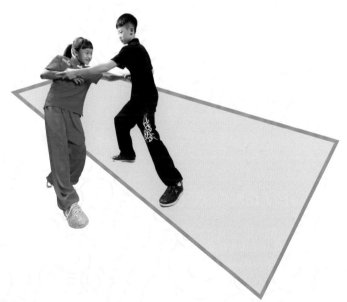

紅方雙腳出界，黑方得 2 分。

If the feet of the red side are out of the boundary, the black side will score 2 points.

鬥士下山：參加戰鬥
Fighter descends the mountain: take part in the battle

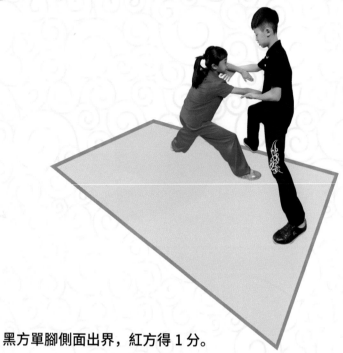

黑方單腳側面出界，紅方得 1 分。

If the black side goes out of the boundary with one foot on the side, the red side will score 1 point.

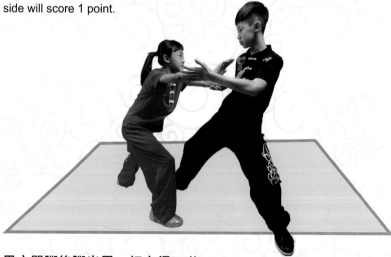

黑方單腳後腳出界，紅方得 1 分。

If the black side goes out of the boundary with one back foot, the red side will score 1 point.

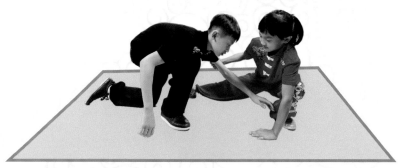

黑方腳觸地，紅方手觸地，互不得分。

If the foot of the black side touches the ground, and the hand of the red side touches the ground, both sides will not score.

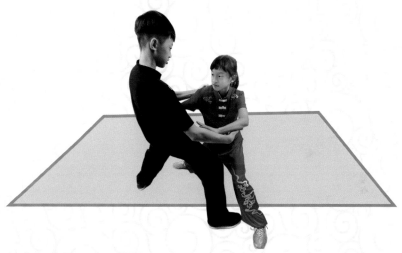

兩人都出界，互不得分。

If both sides are out of the boundary, both of them will not score.

其他：
兩人同時倒地，互不得分。兩人先後倒地，後倒地者得 1 分。
用拳或掌擊打對方犯規。用手拿對方腳犯規。

Others: If both sides fall to the ground at the same time, both of them will not score. If both of them fall to the ground one after another, and the one who fall to the ground later will score 1 point.

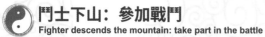

鬥士下山：參加戰鬥
Fighter descends the mountain: take part in the battle

比賽禁例：Bans on competition:

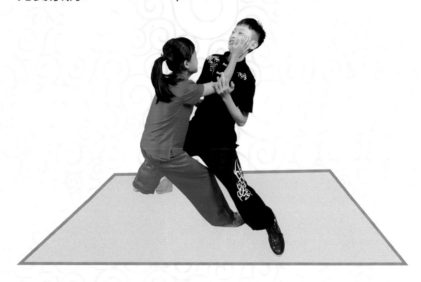

紅方擊黑方面額犯規。

The red side fouls if hit the face of black side.

黑方管腳犯規。

Black side fouls if hooked the foot.

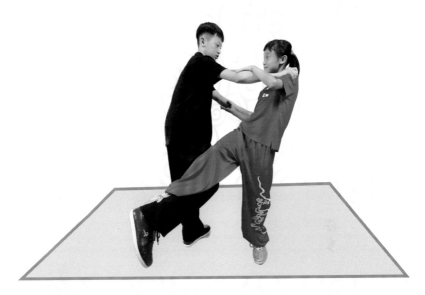

黑方挂腳犯規。

Black side fouls if hung the foot.

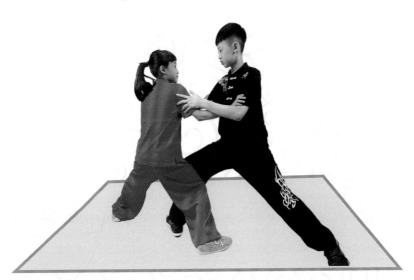

黑方死抓紅方不放犯規。

Black side fouls if firmly caught the red side and did not let go of red side.

鬥士下山：參加戰鬥
Fighter descends the mountain: take part in the battle

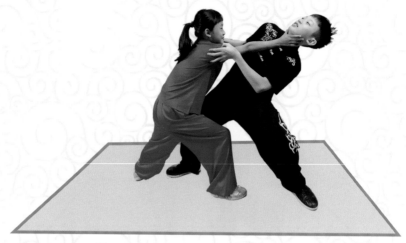

紅方扼住黑方頸喉犯規。

The red side fouls if strangled the neck of black side.

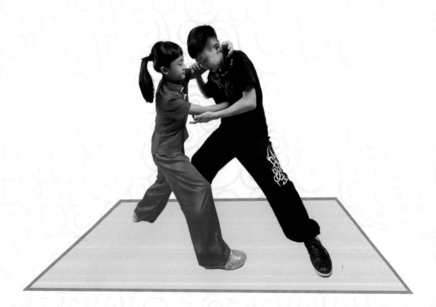

紅方攬黑方頸犯規。

The red side fouls if embraced the neck of black side.

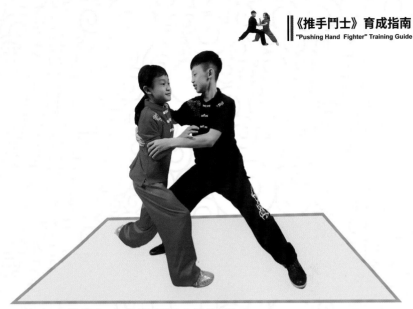

黑方右手攬抱紅方背脊超過中線犯規。

The black side fouls if embraced the red side's spine over the center line with his right hand.

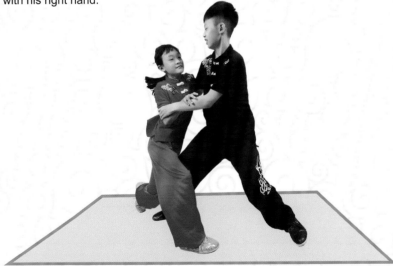

黑方右膝拍打紅方右腳犯規。

The black side fouls if black side's right knee slapped red side's right foot.

其他：用拳或掌擊打對方犯規。用手拿對方腳犯規。

Others: Fouls if hit the opponent with fists or palms. Fouls if held the opponent's foot with hand.

香港氣功太極社簡介

香港氣功太極社自二零零零年正式創立，為本港一非牟利註冊團體。本社旨在弘揚中華文化，研究氣功、太極及武術在香港發展。自創立至今，本社一直匯聚各方有志研習武術的人士，容納各門各派，互補長短，並得到多位大師擔任本社名譽會長、顧問等職

加入 QR code

及武林各界朋友鼎盛支持，努力扶掖後進，推動中國武術在港發展。

本社一直致力推動會員參與各項比賽交流活動，曾先後組織會員參加海南島三亞市舉辦的〝首屆世界太極拳健康大會〞、珠海舉辦的〝中國珠海國際太極拳交流大會〞、"中國焦作第二屆世界太極拳年會"等比賽獲得多個獎項，同時本社亦多次舉辦〝香港‧廣州‧佛山交流團〞、〝河南太極尋根之旅〞等交流團，往國內與各武術團體交流習拳，為本社社員提供一個擴濶視野、增進技術的機會。

另外，本社每年一度的盛事〝傳統武術群英會〞，多年來亦邀請多位大師如王西安大師、陳正雷大師、周盟淵大師、王戰軍師傅、王戰海師傅、王海軍師傅、蔡長慶師傅、張修林大師、陳瑜師傅、傅清泉師傅、陳炳添師傅、趙增福大師、劉綏濱掌門、鍾振山師傅、趙宏偉師傅、釋行者大師、釋延康大師等來港參與匯演，並予以指導。

本社亦參予多項社會服務，包括為地區團體演出、參與慶回歸五周年紀念活動等，積極推動太極於區內發展。

2002 年邀請王西安大師，周盟淵大師等來港，於黃大仙騰龍墟"傳統武術群英會"表演，是日吸引了 13 萬香港市民入場觀賞，傳媒廣泛報導，實為香港武林盛事。

自 03 年開始，本社出版【金剛動靜氣功】及【金剛動靜氣功】講習碟，讓會員市民更易學習。同年 5 月，與少林寺及香港文化促進會推動【易筋強身心連心 運動健體抗炎日】及獲邀參加【全城抗炎啟動禮抗炎活動日】等活動教授數以千計參加者陳家溝太極健體 8 式。

Hong Kong Qigong Taiji Association

Hong Kong Qigong Taiji Association was officially established in 2000 as a non-profit registered organization in Hong Kong. The club aims to promote Chinese culture and study the development of Qigong, Tai Chi and martial arts in Hong Kong. Since its establishment, the club has always brought together people interested in learning martial arts, accommodated various sects and schools, complemented each other's strengths and weaknesses, and received the full support of many masters as Honorary Presidents and consultants of the club and friends from all walks of life in the Wulin, so as to support the backward and promote the development of Chinese martial arts in Hong Kong.

The club has always been committed to promoting its members to participate in various competitions and exchange activities. It has successively organized its members to participate in the "First World Taijiquan health conference" held in Sanya, Hainan Island, the "China Zhuhai International Taijiquan exchange conference" held in Zhuhai, and the "China Jiaozuo Second World Taijiquan annual conference" and won many awards, At the same time, the club has held many exchange groups such as "Hong Kong Guangzhou Foshan exchange group" and "Henan Taiji root seeking Tour" to exchange and practice boxing with various martial arts groups in China, so as to provide members of the club with an opportunity to expand their horizons and improve their skills.

In addition, the club's annual grand event "traditional Wushu group meeting" has also invited many masters over the years, such as Master Wang Xi'an, master Chen zhenglei, master Zhou Lianyuan, Master Wang Zhanjun, Master Wang Zhanhai, Master Wang Haijun, master Cai Changqing, Master Zhang Xiulin, master Chen Yu, master Fu Qingquan, master Chen Bingtian, master Zhao Zengfu, Master Liu Suibin, master Zhong Zhenshan Master Zhao Hongwei, master Shi Walker and master Shi Yankang came to Hong Kong to participate in the performance and give guidance.

The club also participated in a number of social services, including performing for regional groups and participating in activities to celebrate the fifth anniversary of the reunification, so as to actively promote the development of Tai Chi in the region.

In 2002, Master Wang Xi'an and master Zhou Lianyuan were invited to Hong Kong to perform at the "traditional martial arts group meeting" in Tenglong market, Wong Tai Sin. On that day, 130000 Hong Kong citizens were attracted to watch. The media widely reported that it was a great event in Hong Kong's Wulin.

Since 2003, we have published the "Vajra dynamic and static qigong" and "Vajra dynamic and static qigong" lecture discs to make it easier for members to learn. In May of the same year, he worked with Shaolin Temple and the Hong Kong Council for the promotion of culture to promote the "easy muscle, strong body, heart to heart exercise anti-inflammatory day" and was invited to participate in the "city wide anti-inflammatory launching ceremony anti-inflammatory activity day" and other activities to teach thousands of participants Chen Jiagou Taiji body-building 8.

社監會長理事會芳名

名譽社監
陳婉嫻　陳鑑林　陳協平　陳俊輝　黃齊中　陳　平　徐阮小玲

社　監
貝鈞奇

榮譽會長
閻惠昌 鄧國容

名譽會長
王西安　陳正雷　趙增福　董增辰　駱佩玨　陸　地　陳永如
周盟淵　蔡玉建　陳炳添　陳　瑜　傅清泉　張修林　李法均
劉綏濱　趙宏偉　劉治良　釋行者　釋延康　劉清道　鐘振山
釋恒藝　李文欽　毛明春

名譽顧問
王戰軍　王戰海　王海軍　馮軍利　李雅芳　蔡長慶　應　穎
董大德　劉紹光　莫洛琦　王子天　戚谷華　林耀明　李孝全
王俊棠　尹揚明　曾航生　梁安祺　林俊生　黃國龍　馬如彪
盧偉強　危鳳池　鄒　強　徐　成　楊嘉寬　酈錫舜　董鄭小芬
歐陽錦開　劉德垚垚　黎麗芝　張國泰　張國華　梁鴻基
何顯輝　關明偉　歐佩華　張福財　楊菁菁　譚定邦　關錫華
楊菁菁　張偉良　陸松茂　巫朝暉　葉滿棠　張家偉　鮑月霞
陳國華　李天金　閻素洁　樊帥鑫

顧　問
關永生　陳　略　張慧嫻　李添成　林　暢　岑錦鴻　楊創雲
余藹祥　楊家輝　施雄鵬　李子建　陳美霞　楊曼碩　陳貝蒂
黃蓮英　謝延虎　周　強　陳麗嬋　萬榮佳　談秀媚　車崇健
李昌發　楊玉貞　陳美霞

義務法律顧問
陳曼琪律師

學術顧問
謝寶笙博士　劉志宏博士　歐陽錦超　張仁康

會　長
林文輝

副會長
區柏就 卓清

秘書長
林樂

秘　書
蕭惠萍

司　庫
陳文健 黃秀珍

總幹事
傅深桂

理　事

郭嘉炎	林文偉	黃秀珍	楊桂仙	袁惠東	王佩玉	張　鑒
吳海泉	孫名峰	吳文峰	陳　略	黃志偉	江明國	陳文健
唐偉奇	翟宣彤	梁兆熊	蕭少芳	黃　成	周愛玲	李華耀
勞耀坤	何漢強	黃志彬	徐建謙	黃嬋珍	甄寶琴	李漣漪
彭容賞						

【太極扇】

武術/廣場舞/表演扇

可訂制LOGO

长袖款

短袖款

手工純銅太極劍　神武合金太極劍

龍泉寶刀

黑白漸變仿綢

淺棕色牛奶絲

白色星光麻

女款

男款

男女同款

藍色【經典款】
XF8008-2 藍

黃色【經典款】
XF8008-2 黃色

紫色【經典款】
XF8008-2 紫色

正紅色【經典款】
XF8008-2 正紅

黑色【經典款】
XF8008-2 黑

綠色【經典款】
XF8008-2 綠

桔紅色【經典款】
XF8008-2 桔紅

粉色【經典款】
XF8008-2 粉

【出版各種書籍】

中英文版 English ★★★★

申請書號>設計排版>印刷出品
>市場推廣
港澳台各大書店銷售

冷先鋒